LIVING ORIGAMI

by Takuji Sugimura

translated by Catherine Arthurs

PERENNIAL LIBRARY

Harper & Row, Publishers, New York
Cambridge, Philadelphia, San Francisco
London, Mexico City, São Paulo, Sydney

Published by Ottenheimer Publishers, Inc.
Exclusively distributed by Harper & Row,
Publishers, Inc., New York, New York
10022

Preface

Out of the set patterns of traditional origami, a new kind of "creative origami" has recently emerged, encouraging new expressions of form by an ever-increasing number of enthusiasts in many countries. Even so, Sugimura has written this book because he feels that origami is one of the least recognized and understood art forms among the Japanese cultural traditions now enjoying popularity abroad.

Though sculpture is my field, my friendship with Sugimura and my long companionship with origami have prompted me to write this preface. As a child, I was often ill, spending months in bed, and taking medicine that came in square paper packets. Origami was my childhood playmate, and I spent many happy hours folding shapes from those packets. Perhaps the desire to become a sculptor arose from those early experiences. Living in Paris twenty years ago, I wrote some weekly articles on origami. I was unknown as a sculptor then, but many children became fans of mine through that magazine.

Traditionally origami has been a finger craft for relaxation. If it should become a "serious" art form, I fear its creators might become too possessive of their works. It would be a shame to lose the original spirit of folding for fun without being aware of the creator. I am not opposed to today's creative movement; rather I hope that modern artists will share their work generously and thus encourage the growth of this modest and pleasurable art.

Kakuji Yamamoto
Professor Emeritus
Kyoto Municipal University of Art

Contents

Dove 1(2)
Graceful Waterfowl . . 1 (3)
Giraffe 4 (6)
Elephant 5 (7)
Four-pointed Basket
 (traditional) 8 (11)
Crane (traditional) . . . 9 (10)
Baskets (nine folded
 from a single sheet) . . 12
Twin Four-pointed
 Baskets 13 (97)
Nesting Crane 13 (14)
Three-pointed
 Baskets 16 (18)
Four-pointed
 Tube Baskets . . . 16 (19)
Eight-sided Baskets 17
Nurse's Cap 20 (98)
Giraffe Notepaper . . 20 (22)
Medicine Packets . . 20 (100)
Waterbirds
 in Formation . . . 24 (26)
Scallop Shell 28 (30)
Fish 29 (103)
Squid 29 (102)
Horned Beetle . . . 32 (104)
Swiss Bonnet 33 (34)
Party Hat 33 (67)
Penguins 36 (35)
School of Fish 37 (38)
Four-sided Baskets
 with two points . . 40 (39)
Six-sided Baskets
 with three points . 40 (42)
Three-pointed
 Tube Baskets . . 41 (118)
Waterbird Notepaper . . 44 (43)
Frog Notepaper 44
Elephant Notepaper . . 45 (46)
Three Graceful
 Waterfowl 44
Frog Finger Puppet 48 (108)
Scorpion
 Finger Puppet . . 48 (47)

Puppies
 with their Mother 49 (50)
Friendly Dog 52 (110)
Barking Dog 52 (51)
Dachshund 53 (54)
Dragonfly 56 (58)
Flat Purse 57 (101)
Maple Leaf 57
Fox 60 (55)
Pointed Hat 61 (62)
Baseball Cap 61 (79)
Waterbird Family 64 (63·66)
Crane Origami
 Sculpture 68 (112)
Samurai Helmet . . . 69 (70)
Plump Crane
 (traditional) 72 (74)
Slender Crane 73 (75)
Peaked Cap 76 (99)
Handbag 76 (67)
Fireman's Helmet . . 77 (78)
Star 80 (114)
Basket, Jewel Box, Bracelet
 and
 Decoration 81 (78·82·83)
Snowflakes 84 (86)
Plump Crane
 Notepaper 89 (116)
Dog Notepaper 88
Snow Goose 88 (90)
Duck 88 (91)
Cranes
 Carrying Baskets . 92 (94)
Crane Perched
 on a Turtle 96
Basic Fold A (119)
Basic Fold B (119)
Basic Fold C (120)
Basic Fold D (120)
Basic Fold E (121)
Basic Fold F (122)
Basic Fold G (123)
Translator's Note 124

* Numbers in parentheses indicate folding method pages.

Cover Photo: Nesting Crane
Illustrations: Kiiko Seki & Yasuhiro Fujitate
Photos: C. P. I.

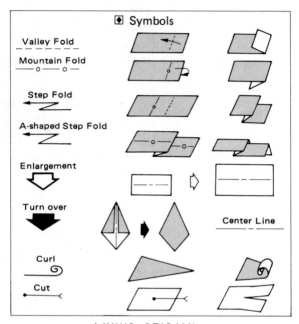

◆ Symbols

Valley Fold

Mountain Fold

Step Fold

A-shaped Step Fold

Enlargement

Turn over

Curl

Cut

Center Line

LIVING ORIGAMI
by Takuji Sugimura
translated by Catherine Arthurs

Copyright © 1983 by Hoikusha Publishing Co., Ltd.
Copyright © 1985 by Ottenheimer Publishers, Inc.

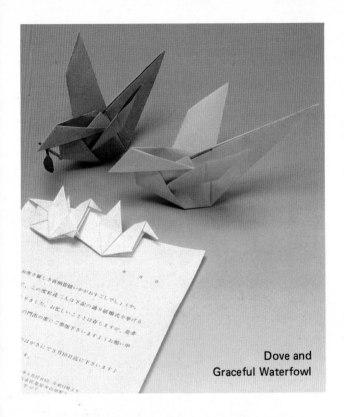

Dove and
Graceful Waterfowl

Living Origami — you can put a lot of feeling into a single piece of paper. In this book I have used traditional folding methods in my own way, taking advantage of the beauty and mystery of paper. I hope you will discover the many possibilities open to you through the techniques and creations shown here.

1

◆ Dove

■ Begin with a rectangle cut to the ratio of 2:3.

①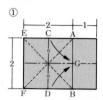

Fold so C and D meet G; E meets A, and F meets B.

②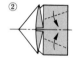

③ Make crease.

④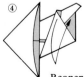

Reopen and tuck flap underneath.

⑤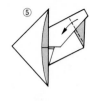

⑥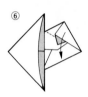

⑦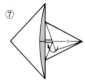

Tuck this flap inside.

⑧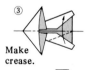

Hood fold

⑨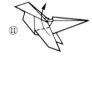

Hood fold

⑩

⑪

⑫ Completion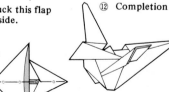

■ Try making the sides of the paper longer or shorter; the bird's shape will be different.

◆ Graceful Waterfowl

■ Start with basic fold C. (Page 120)

①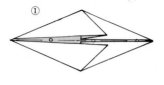

②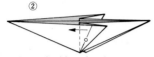

Spread this triangle open into a diamond, front and back.

③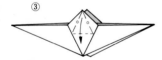

④ ⑤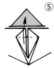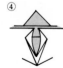

Half way

Fold wing flap up. Turn and repeat.

⑥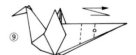

In and down

⑦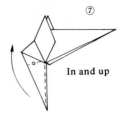

In and up

⑧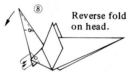

Reverse fold on head.

Fold both sides under.

⑨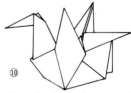

Reopening the body, make a deep A-shaped step fold.

⑩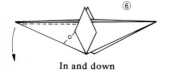

The three lovely birds on page 45 are attached by their tails. One quarter of a large square is cut off, and three birds can be folded with the remaining piece. Only the center bird has no step fold on the tail.

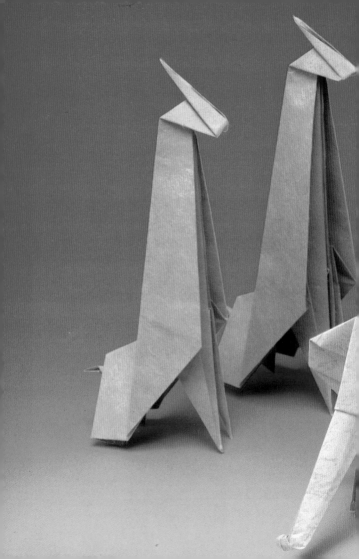

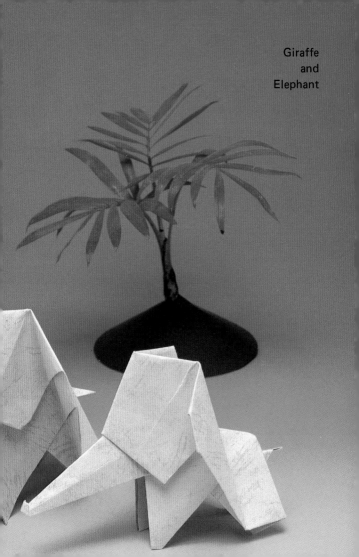

Giraffe
and
Elephant

◈ Giraffe

■ Start with
basic fold C. (Page 120)

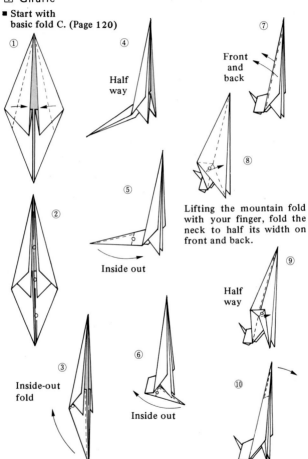

① ② ③ Inside-out fold

④ Half way

⑤ Inside out

⑥ Inside out

⑦ Front and back

⑧ Lifting the mountain fold with your finger, fold the neck to half its width on front and back.

⑨ Half way

⑩

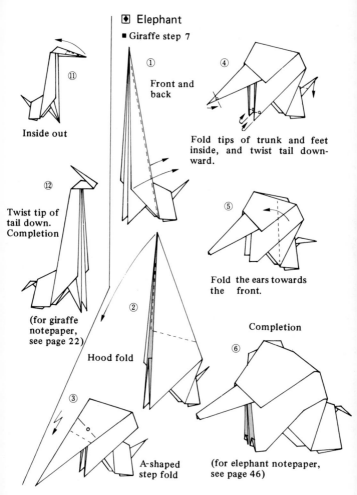

◈ Elephant

■ Giraffe step 7

① Front and back

④ Fold tips of trunk and feet inside, and twist tail downward.

⑤ Fold the ears towards the front.

⑥ Completion

(for elephant notepaper, see page 46)

② Hood fold

③ A-shaped step fold

⑪ Inside out

⑫ Twist tip of tail down. Completion

(for giraffe notepaper, see page 22)

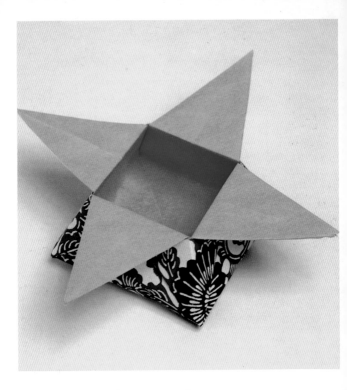

Four-pointed Basket (traditional)

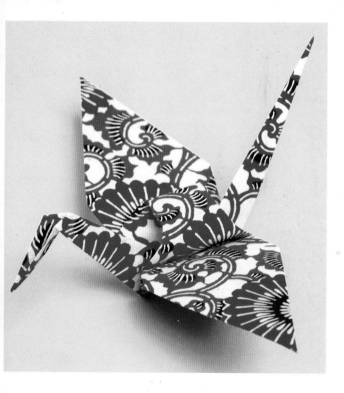

Crane (traditional)

Both the four-pointed basket and the crane are excellent examples of traditional origami. The origami pictured here is of hand-made paper, dyed one color at a time.

9

◆ Crane (traditional)

■ Start with basic fold B. (Page 119)

① Fold top layer only.

④ In and up

② Turn over.

③ Same as above

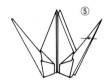

⑤ In and down

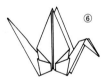

⑥ Pressing lower body closed, slowly open back by pulling wings gently apart.

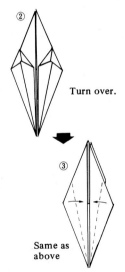

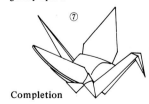

⑦ Completion

◆ Four-pointed Basket (traditional)

- Start with basic fold A. (Page 119)

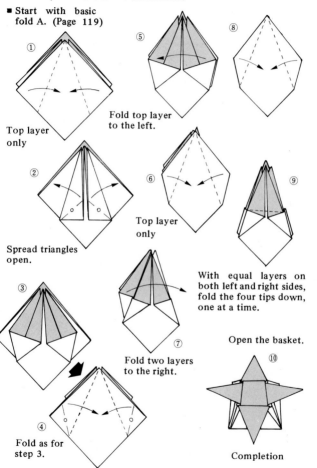

① Top layer only

② Spread triangles open.

③

④ Fold as for step 3.

⑤ Fold top layer to the left.

⑥ Top layer only

⑦ Fold two layers to the right.

⑧

⑨ With equal layers on both left and right sides, fold the four tips down, one at a time.

Open the basket.

⑩ Completion

11

Baskets (nine folded from a single sheet)

This can be folded by making numerous slits in a large square piece of paper. See pages 11 and 97 for details and give it a try!

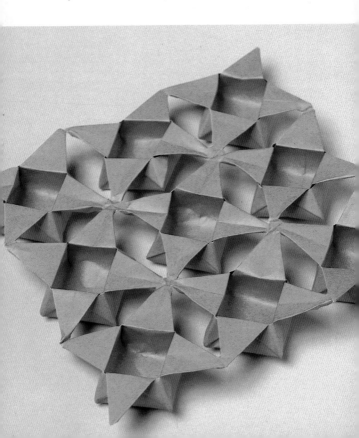

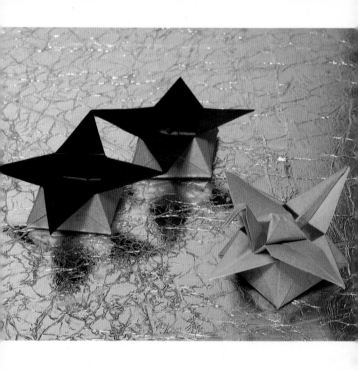

Twin Four-pointed Baskets and Nesting Crane

These are traditional origami combined in an innovative way. From one sheet of paper, two baskets are folded with two points attached. Likewise, the tail and one wing of the crane are attached to two points of the nest. (folding method of the twin baskets page 97)

13

◆ Nesting Crane

■ If you can make the crane and the four-pointed basket, try this.

First make the fold lines. Then make the cut, leaving both ends attached.

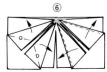

Reopen the crane side, and open and flatten the basket flaps.

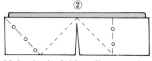

Make basic fold A (Page 119) on both sides.

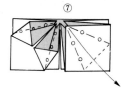

Fold basket flaps under.

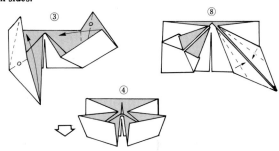

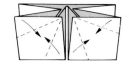

The left half will be a pointed basket, the right half, the crane (see pages 10, 11).

14

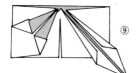

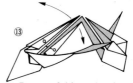

Turn and fold other side to correspond.

Reverse folds on head and tail

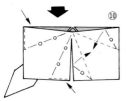

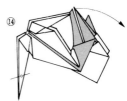

Lifting attached corner gently, tuck sides of crane underneath.

Fold basket points down, opening inside of basket. Make crane's head.

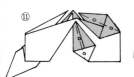

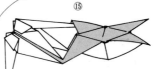

Make the basket the same on both sides.

Slowly pull crane's wings apart, puffing out the body; bring crane up so she sits on the nest.

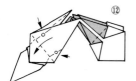

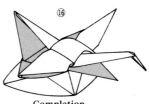

This flap will look like a toboggan. Fold the two sides as you did for step 9.

Completion

Three-pointed Baskets and Four-pointed Tube Baskets

There is one point on each side. The same size and shape of paper was used for each basket of the same group. Only the folding method varies slightly.

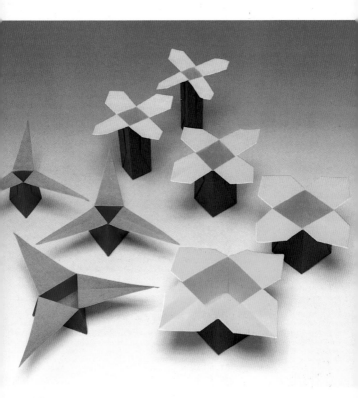

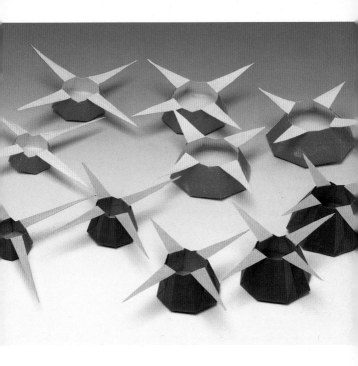

Eight-sided Baskets

Here baskets with eight sides have only four points. The folding method is the same for them all, but the shape of the paper is different.

◆ Three-pointed Basket

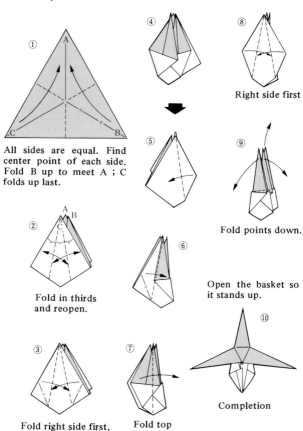

① All sides are equal. Find center point of each side. Fold B up to meet A ; C folds up last.

② Fold in thirds and reopen.

③ Fold right side first, top layer only.

④

⑤

⑥

⑦ Fold top layer over as far as possible.

⑧ Right side first

⑨ Fold points down.

Open the basket so it stands up.

⑩ Completion

◘ Four-pointed Tube Basket

■ Start with basic fold A. (Page 119)

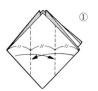

①

Fold in thirds with parallel lines.

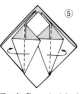

⑤

Tuck flaps behind.

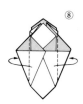

⑧

Tuck flaps behind.

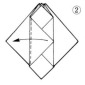

②

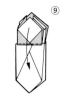

⑥

⑨

Fold points down and open the basket.

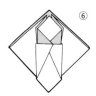

③

Open and flatten.

▼

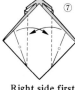

⑦

Right side first

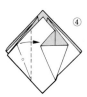

④

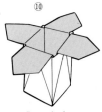

⑩

Completion

19

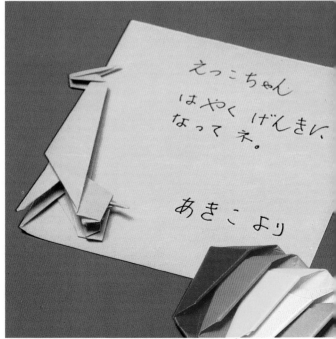

えっこちゃん
はやく げんきに、
なって ネ。

あきこ より

Nurse's Cap
(folding method
page 98)

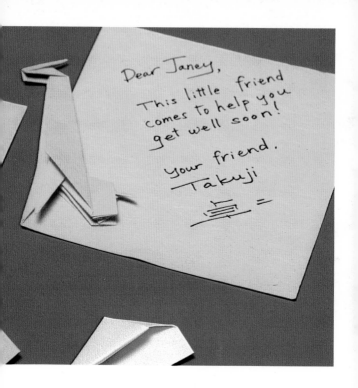

Giraffe Notepaper and Medicine Packets

Origami can be used to make interesting writing paper. This giraffe is part of the letter. (folding method of the medicine packets page 100)

◈ Giraffe Notepaper

■ See giraffe on page 6.

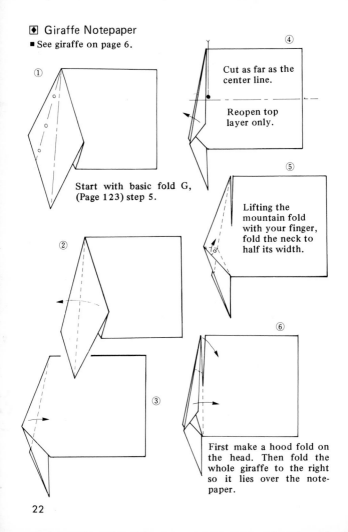

① Start with basic fold G, (Page 123) step 5.

②

③

④ Cut as far as the center line.

Reopen top layer only.

⑤ Lifting the mountain fold with your finger, fold the neck to half its width.

⑥ First make a hood fold on the head. Then fold the whole giraffe to the right so it lies over the note-paper.

22

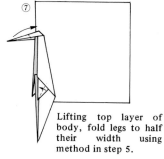

⑦

Lifting top layer of body, fold legs to half their width using method in step 5.

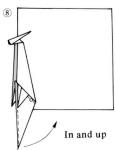

⑧

In and up

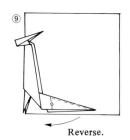

⑨

Reverse.

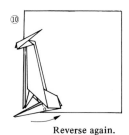

⑩

Reverse again.

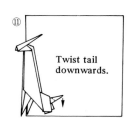

⑪

Twist tail downwards.

⑫

Now your note-paper is ready for your message!

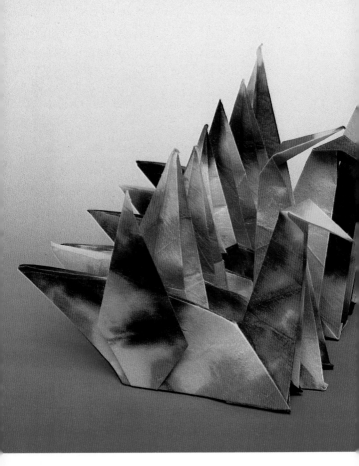

Waterbirds in Formation

24

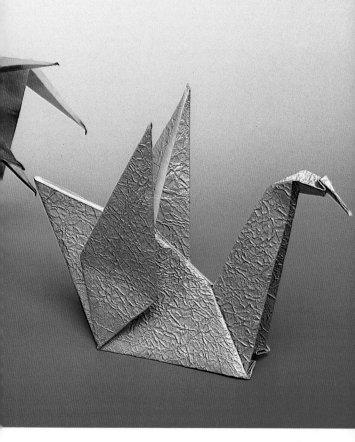

Using one sheet of six-sided paper, these waterbirds are folded with wingtips attached. The single bird is made from a triangle.

◆ Waterbird

■ Folding method for the single bird

① Start with a triangle. Reopen after making the creases.

② Make creases and reopen.

③

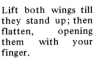

④ Lift both wings till they stand up; then flatten, opening them with your finger.

⑤ Make creases and reopen, on both wings.

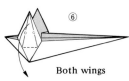

⑥ Both wings

⑦ Both wings

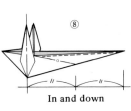

⑧ In and down

⑨ Looking at step 10, grasp point A and pull neck straight down.

26

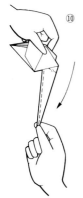

Fold neck again, in and up.

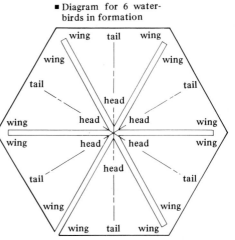

■ Diagram for 6 water-birds in formation

wing tail wing
wing wing
tail tail
head head head
wing wing
wing head head wing
tail tail
head
wing wing
wing tail wing

Both sides

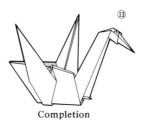

A-shaped step fold

Completion

■ To make the six attached water-birds, cut a 6-sided sheet according to the diagram above. They are attached by their wings.

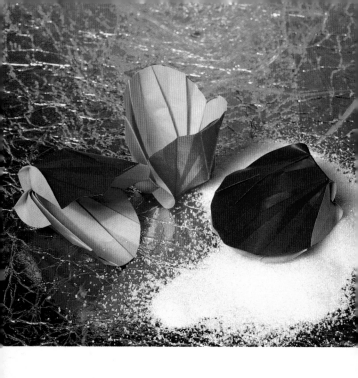

Scallop Shells

A circular sheet of paper was used for the scallop, a rectangular sheet for the fish and squid.

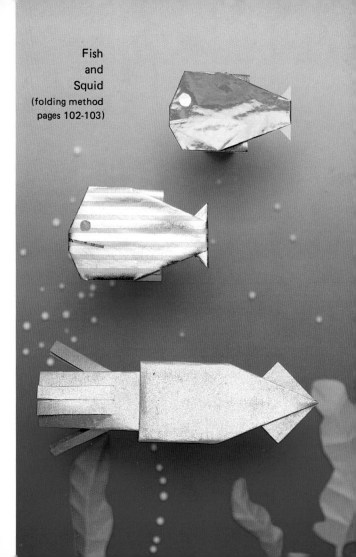

Fish
and
Squid
(folding method
pages 102-103)

◆ Scallop Shell

■ Cut your paper into a circle.

Fold B to A.

Fold B down at center line, then fold C down to meet B, and up again at center.

Fold B to A.

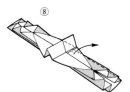

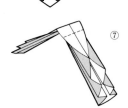

Raise 3 flaps.

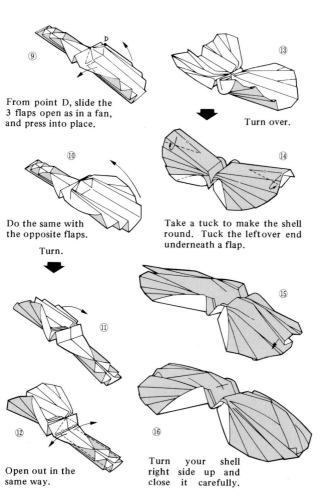

⑨

From point D, slide the
3 flaps open as in a fan,
and press into place.

⑩

Do the same with
the opposite flaps.

Turn.

⑪

⑫

Open out in the
same way.

⑬

Turn over.

⑭

Take a tuck to make the shell
round. Tuck the leftover end
underneath a flap.

⑮

⑯

Turn your shell
right side up and
close it carefully.

Horned Beetle

This is made from one square sheet of paper without using glue or scissors. Only the horns are a separate piece.

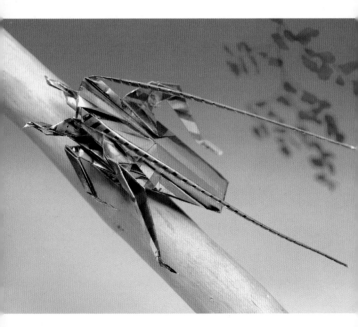

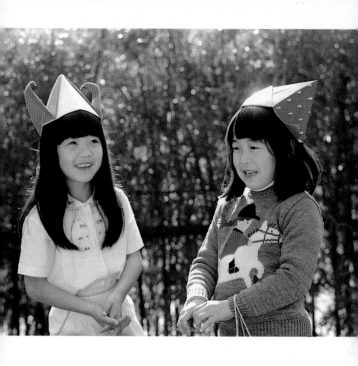

Swiss Bonnet (left) and Party Hat

 To fit a child's head, use a sheet 45-50cm
square (18-20 inches).

◆ Swiss Bonnet

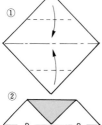

①

②

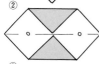

③

Opening the triangle with your finger, fold flat.

⑤

Use basic fold B (Page 119) here.

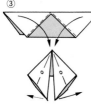

⑥

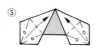

⑦

Open and turn sideways.

⑧

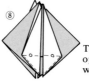

The bonnet is now open and turned sideways.

Inside view

⑨

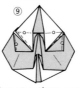

One at a time, open inside flaps and fold the white and gray diamond in and out of sight. Lower half shows this step completed.

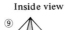

⑩

Fold only the flap, on both sides.

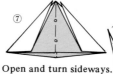

⑪

⑫

Curl the tips by rolling them around a pencil.

34

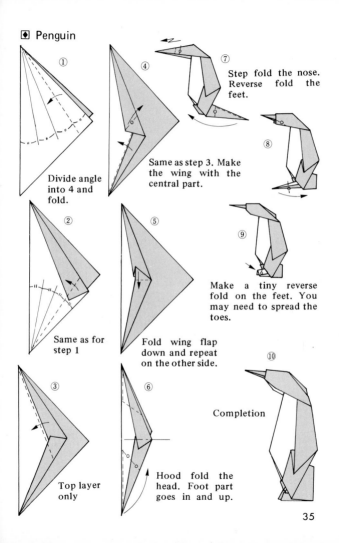

◆ Penguin

① Divide angle into 4 and fold.

② Same as for step 1

③ Top layer only

④ Same as step 3. Make the wing with the central part.

⑤ Fold wing flap down and repeat on the other side.

⑥ Hood fold the head. Foot part goes in and up.

⑦ Step fold the nose. Reverse fold the feet.

⑧

⑨ Make a tiny reverse fold on the feet. You may need to spread the toes.

⑩ Completion

35

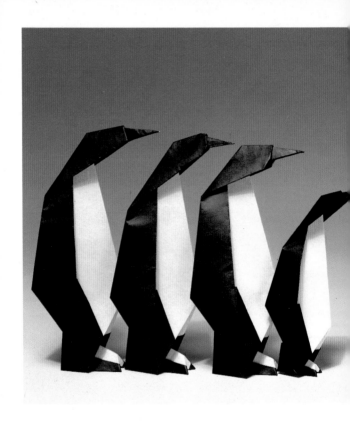

Penguins

If you change the head and feet slightly, you can create quite a variety of penguins.

School of Fish

Try experimenting with the tail and fins. You will find the fish displaying all sorts of different motions.

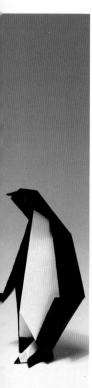

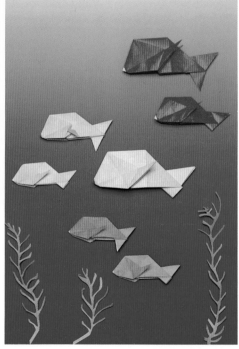

◆ Fish

①

②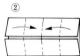

③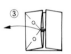

Pull center point out, holding the two lower points down.

④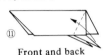

Reopen right half.

⑤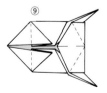

⑥

Entire flaps are folded to the right.

⑦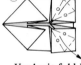

Use basic fold B. (Page 119)

⑧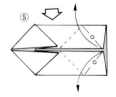

⑨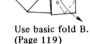

⑩

Pulling mouth out, fold body in half.

⑪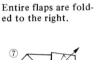

Front and back

⑫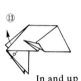

Tail goes in and down.

⑬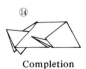

In and up

⑭

Completion

38

◆ Four-sided Basket

■ Use a diamond shape of any width or length you wish.

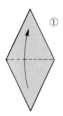

①

②

③

Open flap and press flat.

④

Turn over.

⑤

Repeat previous fold.

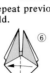

⑥

Fold upper flap to the left, under flap to the right.

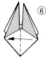

⑦

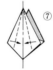

⑧

Turn and repeat.

⑨

⑩

Turn and repeat.

⑪

Fold points outward and open the basket, so it can stand up.

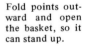

⑫ Completion

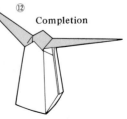

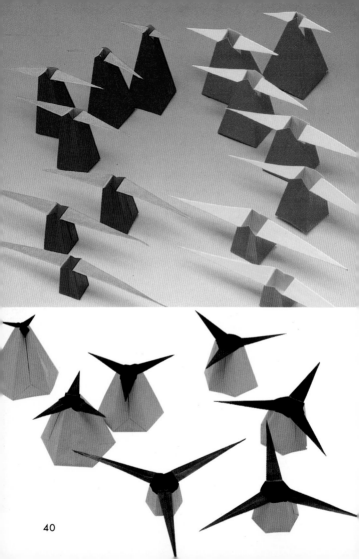

◄ Four-sided Baskets with two points (top left)
and
Six-sided Baskets with three points (lower left)

Three-pointed Tube Baskets

Each basket has three sides and three points. The same size of triangular paper was used to fold both the single basket and the group of four. (folding method page 118)

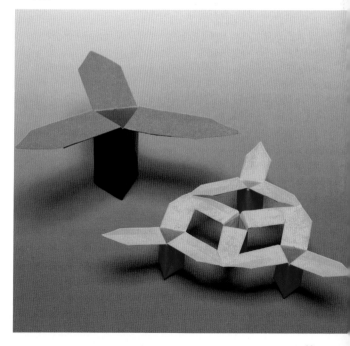

◆ Six-sided Basket

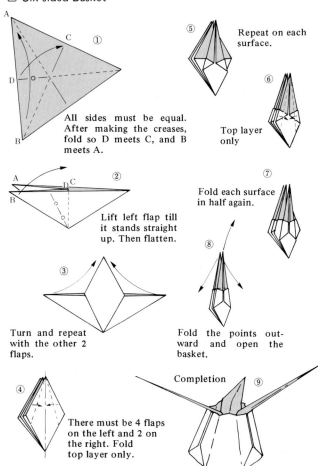

① All sides must be equal. After making the creases, fold so D meets C, and B meets A.

② Lift left flap till it stands straight up. Then flatten.

③ Turn and repeat with the other 2 flaps.

④ There must be 4 flaps on the left and 2 on the right. Fold top layer only.

⑤ Repeat on each surface.

⑥ Top layer only

⑦ Fold each surface in half again.

⑧ Fold the points outward and open the basket.

⑨ Completion

42

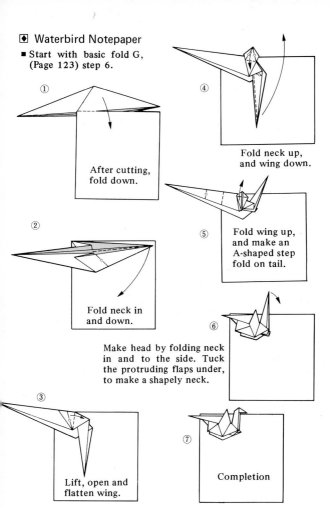

◆ Waterbird Notepaper

■ Start with basic fold G, (Page 123) step 6.

① After cutting, fold down.

② Fold neck in and down.

③ Lift, open and flatten wing.

④ Fold neck up, and wing down.

⑤ Fold wing up, and make an A-shaped step fold on tail.

⑥ Make head by folding neck in and to the side. Tuck the protruding flaps under, to make a shapely neck.

⑦ Completion

The frog folding method is traditional origami. The folding method for one graceful waterfowl is on page 3. No explanation is given for the group of three, or for the frog notepaper, but try making them on your own.

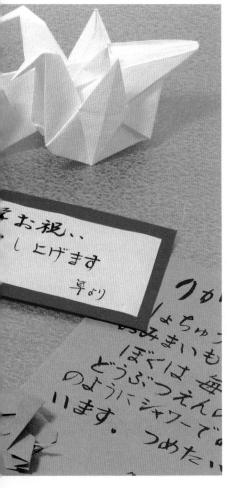

Notepaper
with Waterbird,
Frog or
Elephant
and
Three Graceful
Waterfowl

◉ Elephant Notepaper

■ Start with giraffe note-paper, (Page 22) step 6.

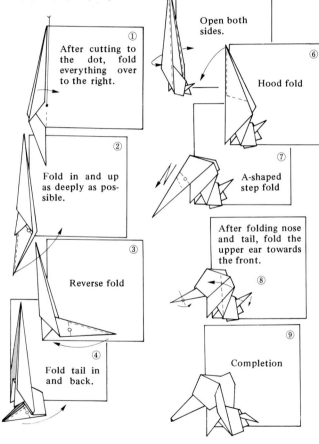

① After cutting to the dot, fold everything over to the right.

② Fold in and up as deeply as possible.

③ Reverse fold

④ Fold tail in and back.

⑤ Open both sides.

⑥ Hood fold

⑦ A-shaped step fold

⑧ After folding nose and tail, fold the upper ear towards the front.

⑨ Completion

46

◆ Scorpion Finger Puppet (created by Jill Abilock)

■ Basic fold B.
(Page 119)

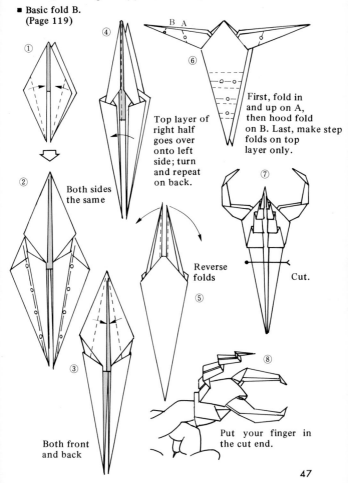

①

② Both sides the same

③ Both front and back

④ Top layer of right half goes over onto left side; turn and repeat on back.

⑤ Reverse folds

⑥ First, fold in and up on A, then hood fold on B. Last, make step folds on top layer only.

⑦ Cut.

⑧ Put your finger in the cut end.

47

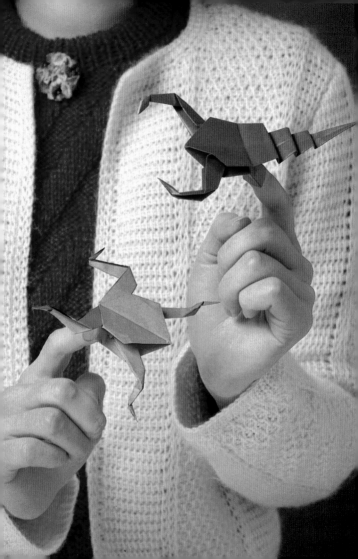

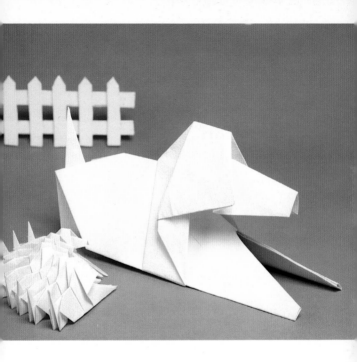

◀ Finger Puppets: Frog and Scorpion

Jill Abilock from the U.S.A. created these finger puppets after only one lesson in origami. (folding method of the frog pages 108-109)

▲ Puppies with their Mother

Nine puppies, attached by their front paws, are folded from one large square of paper. No glue!

49

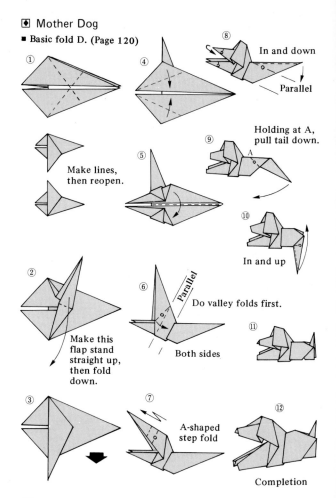

◨ Mother Dog

■ Basic fold D. (Page 120)

①

④

⑧ In and down
Parallel

Make lines, then reopen.

⑤

Holding at A, pull tail down.

A

⑩ In and up

② Make this flap stand straight up, then fold down.

⑥ Parallel
Do valley folds first.
Both sides

⑪

③

⑦ A-shaped step fold

⑫ Completion

◆ Barking Dog

■ Start with the mother dog, step 8.

①

②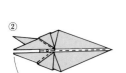

Fold legs down after making 3 valley folds.

③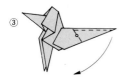

In and down

④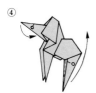

In and up on tail

⑤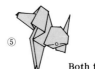

Both flanks

⑥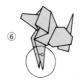

Enlargement of feet in step 6

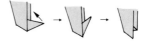

⑦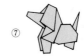

Woof

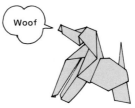

Completion

51

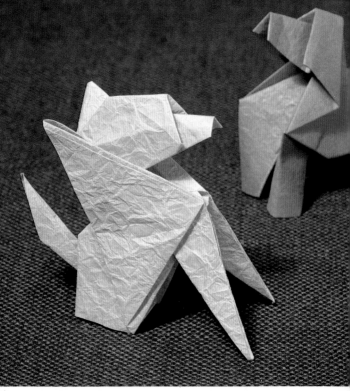

The barking dog (center) is folded from a square
paper. The dachshund uses almost the same folding

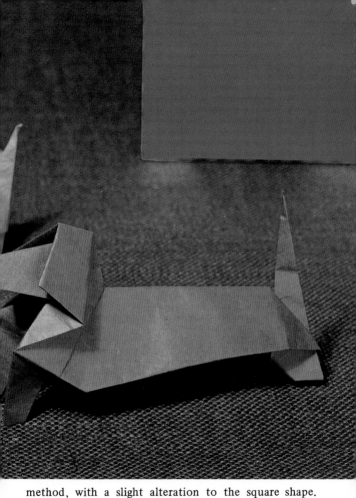

method, with a slight alteration to the square shape.
(folding method of the friendly dog pages 110-111)

◆ Dachshund

- Start with basic fold E. (Page 121)

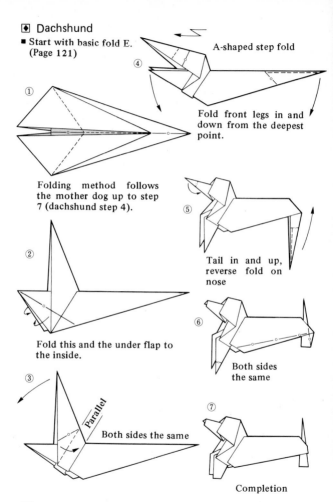

① Folding method follows the mother dog up to step 7 (dachshund step 4).

② Fold this and the under flap to the inside.

③ Parallel
Both sides the same

④ A-shaped step fold
Fold front legs in and down from the deepest point.

⑤ Tail in and up, reverse fold on nose

⑥ Both sides the same

⑦ Completion

54

◆ Fox

- Start with the friendly dog step 6 (page 111).

3a 4a 5a

Rear view of tail. Insert pencil to enlarge opening. Then flatten sideways so tail points away from body.

① Fold both sides of head, and reverse fold the tail.

④ Tail is half open. Hood fold on head

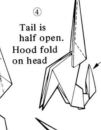

② Reopen the head, and hood fold the tail.

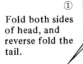

③ Holding head flat with one hand, lift ear open and down with other hand. Do both ears.

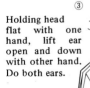

⑤ Lift both ears.

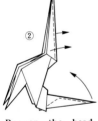

⑥ Flatten head and pull out the flaps hidden underneath.

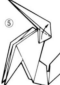

⑦ **Half way**

⑧ Fold the tip under.

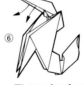

⑨ Make the jaws slimmer.

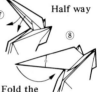

⑩ Completion

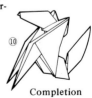

55

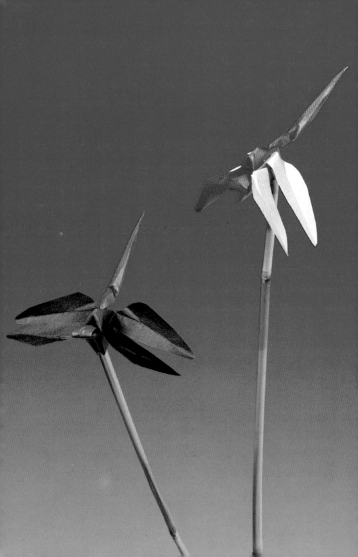

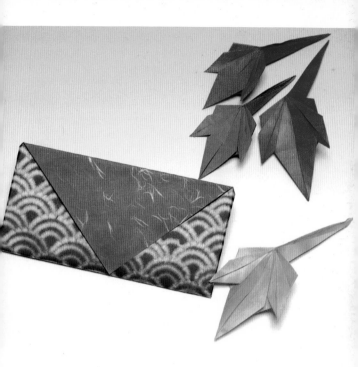

Flat Purse and Maple Leaf
(folding method of the flat purse page 101; no explanation of the maple leaf)

◀ **Dragonfly**

You can fold this from a square piece of paper, but it must be trimmed to the shape of a star.

57

�É Dragonfly

■ Start with the slender crane step 7 (page 75).

①

③ Both sides in and up

⑥

In and sideways

Be careful! The right and left sides are different.

②

④ Roll head like a jelly roll. Reverse fold on tail.

⑦ Puff out body by pulling wings gently apart.

⑤ Pinch neck till thin.

Turn and repeat, making sure front and back match.

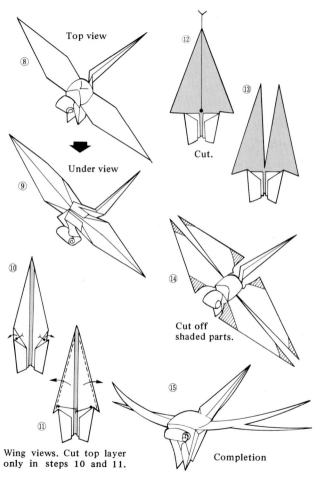

Top view

⑧

Under view

⑨

⑩

⑪

Wing views. Cut top layer only in steps 10 and 11.

⑫

⑬

Cut.

⑭

Cut off shaded parts.

⑮

Completion

59

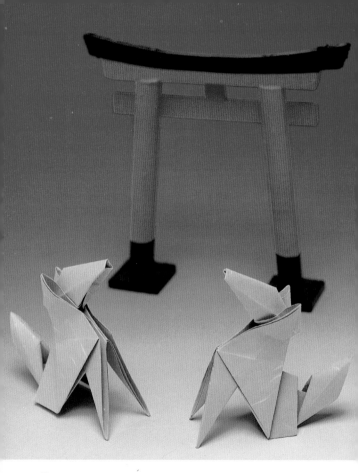

Fox

Stone statues representing the fox god can be found at the gate of Inari Shrines.

Pointed Hat and Baseball Cap
(folding method of the baseball cap page 79)

61

◆ Pointed Hat

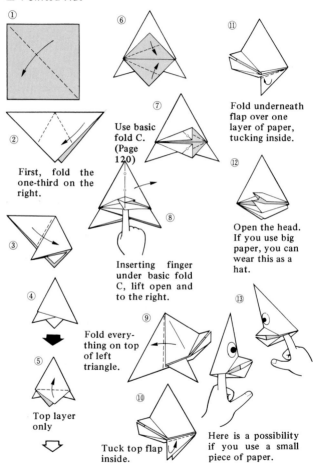

①

② First, fold the one-third on the right.

③

④

⑤ Top layer only

⑥

⑦ Use basic fold C. (Page 120)

⑧ Inserting finger under basic fold C, lift open and to the right.

⑨ Fold everything on top of left triangle.

⑩ Tuck top flap inside.

⑪ Fold underneath flap over one layer of paper, tucking inside.

⑫ Open the head. If you use big paper, you can wear this as a hat.

⑬ Here is a possibility if you use a small piece of paper.

62

◉ Waterbird Family (folding method for the father bird)

■ Basic fold C. (Page 120)

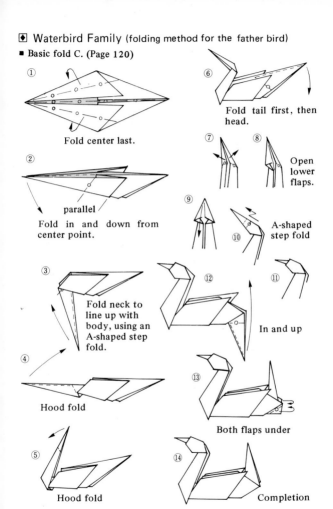

① Fold center last.

② Fold in and down from center point.

parallel

③ Fold neck to line up with body, using an A-shaped step fold.

④ Hood fold

⑤ Hood fold

⑥ Fold tail first, then head.

⑦

⑧ Open lower flaps.

⑨

⑩ A-shaped step fold

⑪

⑫ In and up

⑬ Both flaps under

⑭ Completion

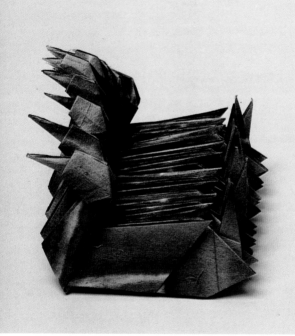

Waterbird Family

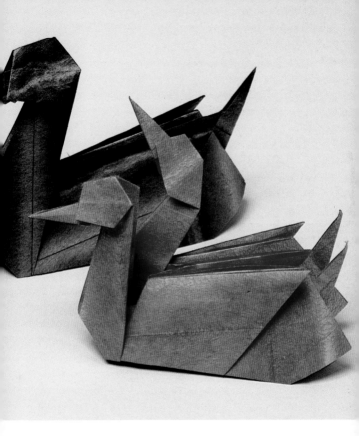

Both the nine gray birds and the two red birds are made from one sheet of paper. Why don't you try making the nine young ones using the folding method of the adult birds.

◉ Twin Waterbirds

■ Start with basic fold G, (Page 123) step 7.

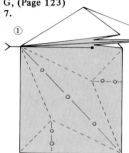

①

Cut as far as the dot. Make basic fold C (Page 120) on lower square, but it must be folded in half to match the upper part.

②

Fold both birds up to step 2 of the father bird page 63.

③

Now fold as in step 4 of the father bird.

④

Fold the heads and necks of both birds.

⑤

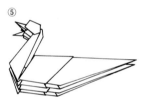

Follow the father bird, steps 12 and 13.

⑥

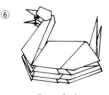

Completion

66

◆ Handbag (page 76)

①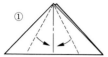

Start with a square folded in half.

②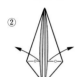

Open flaps and flatten.

③

Fold to the back.

④

Turn over.

⑤

⑥

Both front and back

⑦

Tuck both points under.

⑧

Press sides inward.

⑨

⑩

Attach string handles and you have a handbag.

◆ Party Hat (page 33)

■ Start with handbag step 9.

②

Curl these points downward with a pencil.
Turn over.

①

③

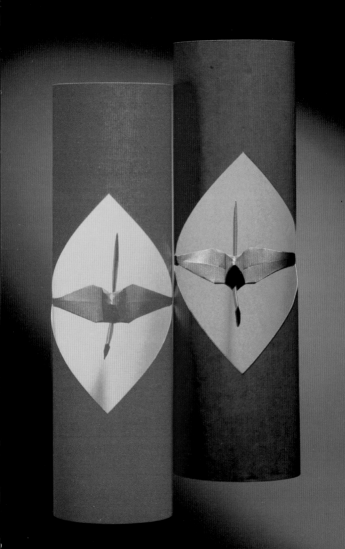

◀ Crane Origami Sculpture
(folding method pages 112-113)

Samurai Helmet

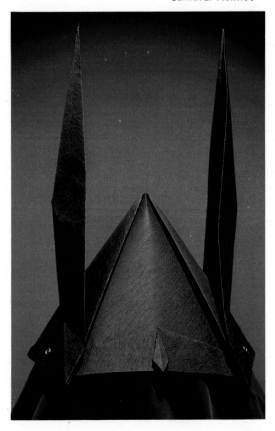

◆ Samurai Helmet

① Cut off white parts.

②

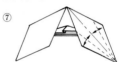

③ Reopen.

④ Top layer only

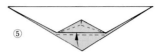

⑤ Fold lower triangle up under upper one.

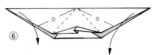

⑥ First make valley folds and reopen. Fold sides open and down.

⑦ Make lines and reopen.

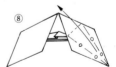

⑧ Like the crane's wings

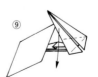

⑨ Fold ear flap down.

70

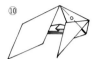

⑩ Fold edge behind.

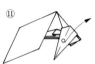

⑪ Up and to the right

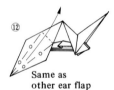

⑫ Same as other ear flap

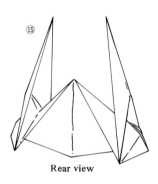

Completion

⑮

Rear view

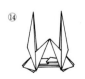

⑬ Hood folds

⑭ Open helmet.

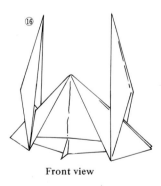

⑯

Front view

71

Plump Crane (traditional) and Slender Crane

The folding method for these two is similar. The shape of the paper is different. This is an example of what you can do by changing the shape of the paper.

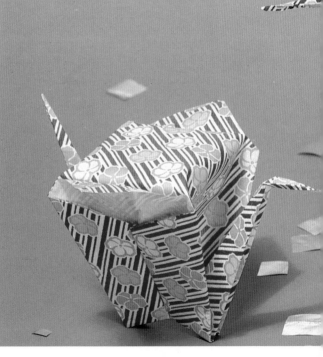

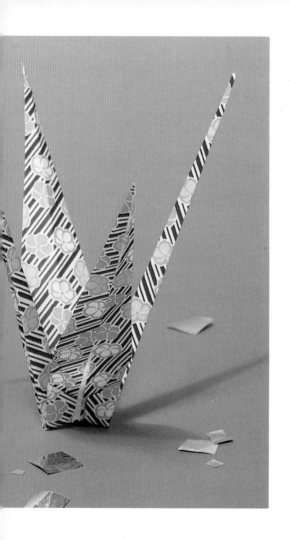

◈ Plump Crane (traditional)

■ Start with basic fold A. (Page 119)

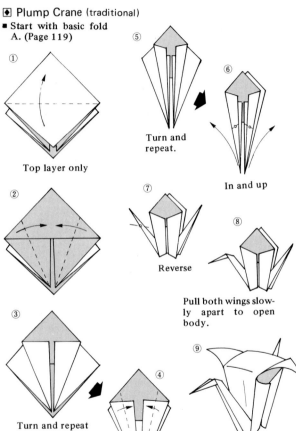

① Top layer only

②

③ Turn and repeat steps 1 and 2.

④ Top layer only

⑤ Turn and repeat.

⑥ In and up

⑦ Reverse

⑧ Pull both wings slowly apart to open body.

⑨ Notepaper featuring this crane is on page 89.

74

◆ Slender Crane

■ Start with basic fold F. (Page 122)

①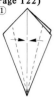

Top layer only

②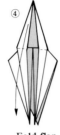

Reopen.

③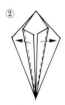

Top layer only. Use previous fold lines. It does not open completely.

④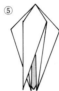

Fold flap down.

⑤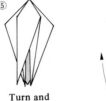

Turn and repeat.

⑥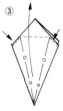

Front and back flaps

⑦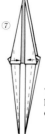

Top layer only

⑧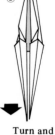

Turn and repeat.

⑨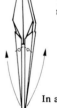

In and up

⑩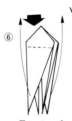

Slowly pull wings apart to puff out body.

⑪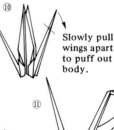

Completion

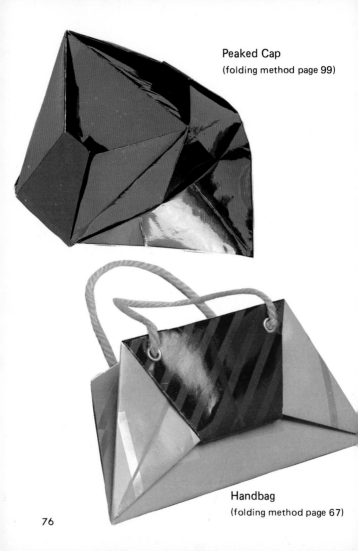

Peaked Cap
(folding method page 99)

Handbag
(folding method page 67)

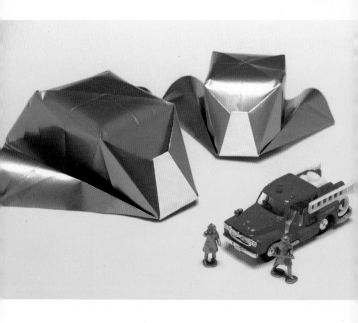

Fireman's Helmet

The same basic folds are used for this helmet, the baseball cap (page 79) and the basket (page 78). They were derived from the traditional four-pointed basket.

◉ Basket

■ Start with basic fold A. (Page 119)

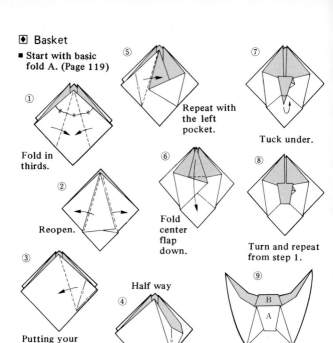

① Fold in thirds.

② Reopen.

③ Putting your finger inside this pocket, fold open and flatten.

④ Half way

⑤ Repeat with the left pocket.

⑥ Fold center flap down.

⑦ Tuck under.

⑧ Turn and repeat from step 1.

⑨ Spread completed basket open.

◈ Fireman's Helmet

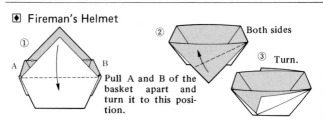

① Pull A and B of the basket apart and turn it to this position.

② Both sides

③ Turn.

78

◆ Baseball Cap (page 61)

- Same as fireman's helmet, step 1.

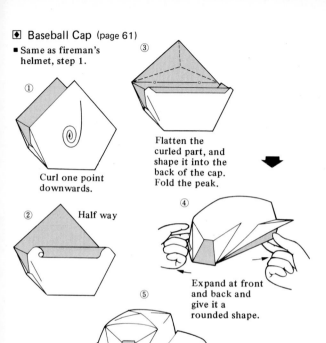

① Curl one point downwards.

② Half way

③ Flatten the curled part, and shape it into the back of the cap. Fold the peak.

④ Expand at front and back and give it a rounded shape.

⑤ Completion

④ Expand sideways.

⑤ Completion

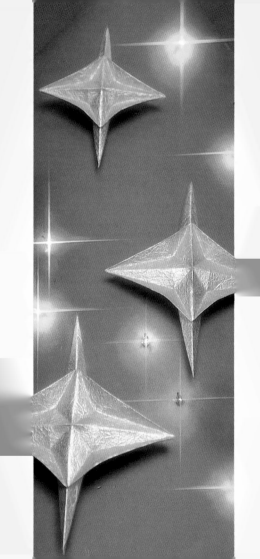

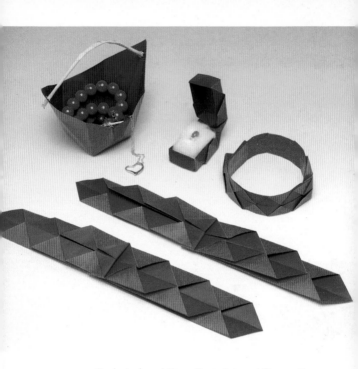

Basket, Jewel Box, Bracelet and Decoration
(folding method of the basket page 78)

◀ Star

I created this star to hang on a Christmas
tree. (folding method pages 114-115)

◆ Jewel Box

■ Start with decoration, step 5.

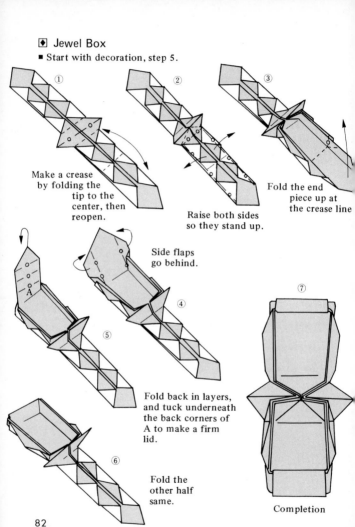

① Make a crease by folding the tip to the center, then reopen.

② Raise both sides so they stand up.

③ Fold the end piece up at the crease line

④ Side flaps go behind.

⑤ Fold back in layers, and tuck underneath the back corners of A to make a firm lid.

⑥ Fold the other half same.

⑦

Completion

82

◆ Decoration and Bracelet

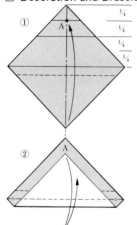

① A

	¼
	¼
	¼
	¼

② A

Fold top layer down at center line, then remaining piece down to meet the point exactly. Fold this new top layer up again at center line, and the lower half up again to meet point A.

③ A

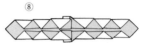

④ A

⑤

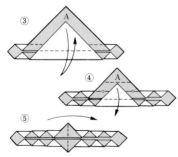

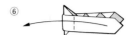

⑥

Fold back top layer at the valley fold.

⑦

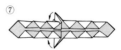

Tuck flaps inside.

⑧

This is the completed multi-purpose decoration.

⑨

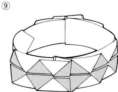

You can make this bracelet by joining two of these decorations.

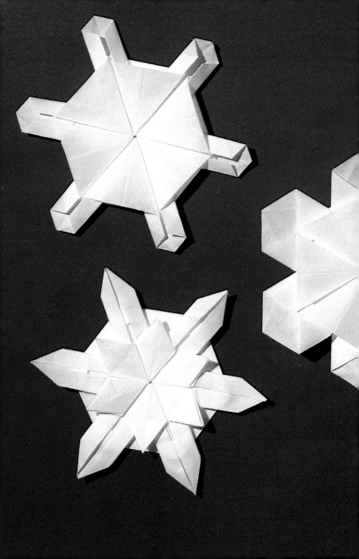

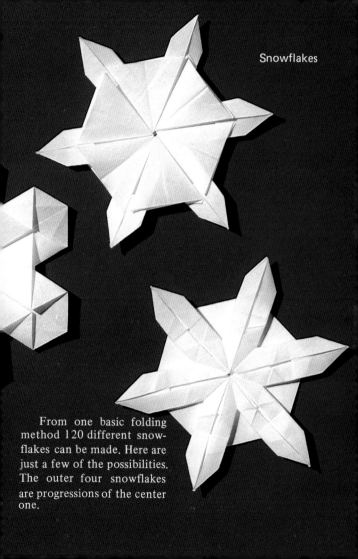

Snowflakes

From one basic folding method 120 different snowflakes can be made. Here are just a few of the possibilities. The outer four snowflakes are progressions of the center one.

◆ Snowflake

■ 6 sided paper

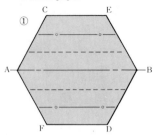

① C E

A B

F D

② A B

Reopen and make the same lines as step 1 using C D as center line, then once again with E F as center line.

④

Steps 4, 5 and 6 show details of how to get to step 7, using one of the six points.

⑤

⑥

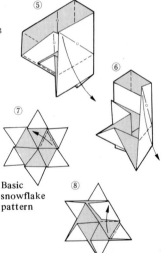

③

Using previous lines, follow steps 4, 5 and 6 carefully to make the basic snowflake pattern.

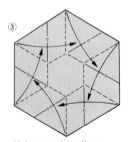

⑦

Basic snowflake pattern

⑧

Fold the remaining 5 points the same.

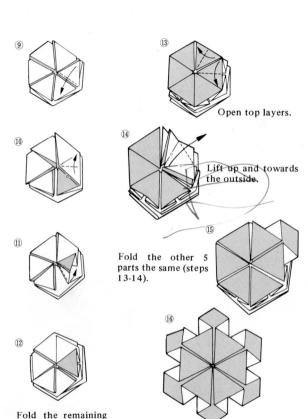

⑨

⑩

⑪

⑫

Fold the remaining 5 triangles the same (steps 9-12).

⑬

Open top layers.

⑭

Lift up and towards the outside.

⑮

Fold the other 5 parts the same (steps 13-14).

⑯

Paper that is white on both sides will look like a real snowflake. By halving the width of the points, you can make the upper left snowflake on page 84.

Notepaper with Plump Crane or Dog

Dear Patricia,
Here's the messenger dog for you on y

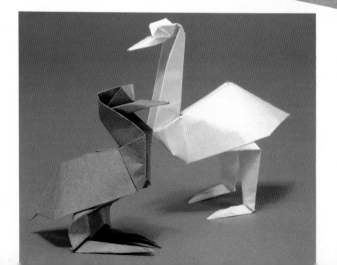

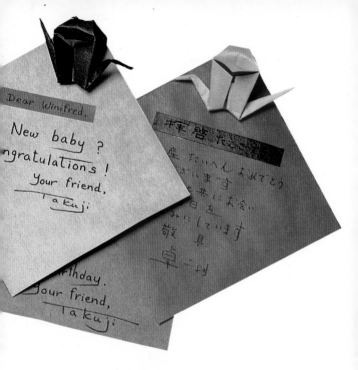

The folding method for the plump crane is on pages 116-117. The dog notepaper uses the folding method of the mother dog on page 50.

◀ Snow Goose and Duck
 You can fold the duck simply by shortening the neck and legs of the snow goose.

◆ Snow Goose

■ Start with basic fold D. (Page 120)

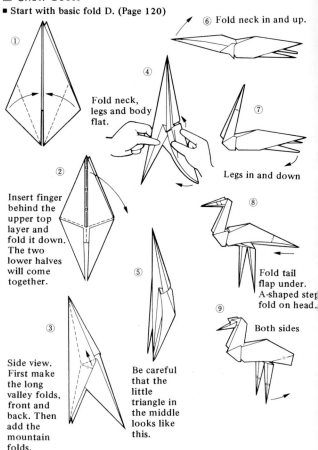

①

② Insert finger behind the upper top layer and fold it down. The two lower halves will come together.

③ Side view. First make the long valley folds, front and back. Then add the mountain folds.

④ Fold neck, legs and body flat.

⑤ Be careful that the little triangle in the middle looks like this.

⑥ Fold neck in and up.

⑦ Legs in and down

⑧ Fold tail flap under. A-shaped step fold on head.

⑨ Both sides

⑩

Legs back,
then forward.

Front view

Rear view

⑪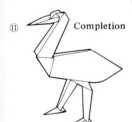

Completion

■ Try changing the body shape and the neck and leg length. You can easily make a duck.

◆ Duck

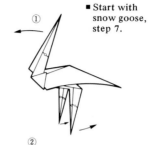

① ■ Start with snow goose, step 7.

② A-shaped step fold

③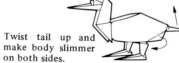

Twist tail up and make body slimmer on both sides.

④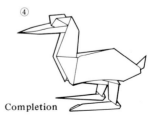

Completion

91

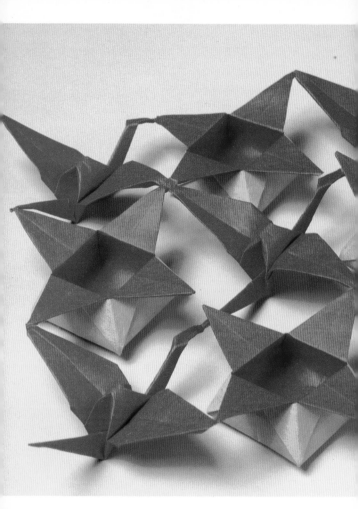

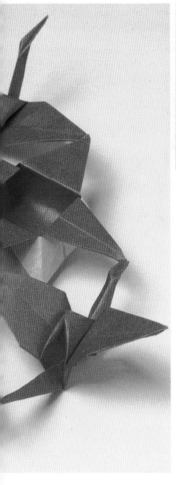

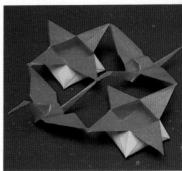

Cranes Carrying Baskets

To make the group of five cranes with four baskets, refer to the method used for the two cranes with two baskets on the next page. The possibilities of multiple origami are endless. Starting from the methods in this book, you can develop your own in many different directions.

◆ Cranes Carrying Baskets (two cranes and two baskets)

■ Not all steps are included here, but you can fold this by referring to the individual crane and basket.

①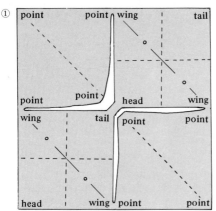

Make these folds, then the cuts, on a large square sheet.

②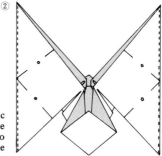

The two center parts (basic fold A) (Page 119) are the cranes. The side parts (also basic fold A) are the baskets.

③ Use the folding method for the four-pointed basket (page 11) on the sides.

④

⑤ Basic fold A

On the central part, the top flap of each crane must be folded to the right, and the bottom flap to the left. Then continue with basic fold B. (Page 119)

⑥

Completion

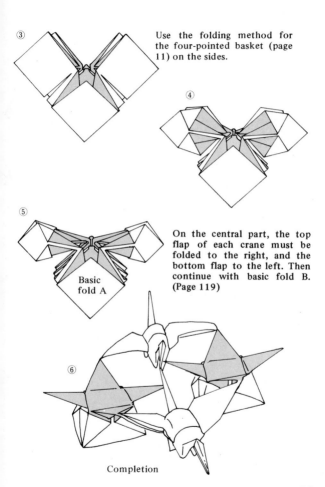

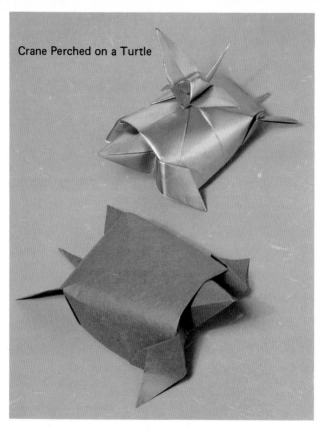

Crane Perched on a Turtle

In Japan, both the crane and the turtle are symbols of long life. The folding method is not explained in this book, but you can find it in the Japanese version entitled "Kawari Origami" (変わりおりがみ).

◈ Twin Four-pointed Baskets (page 13)

- Start with the nesting crane, step 5 (page 14).

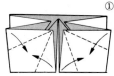

① Fold front and back the same.

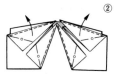

② Open and flatten all 8 triangles.

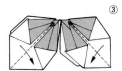

③ Fold the outer top flaps down.

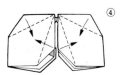

④ Top flaps only

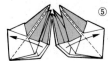

⑤ Fold the central parts (two layers each) to the outside, and repeat step 4.

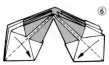

⑥ Top layer only

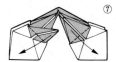

⑦ Fold points down carefully one by one.

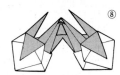

⑧ Gently open the baskets.

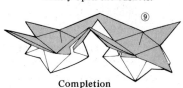

⑨ Completion

◆ Nurse's Cap (page 20)

■ Fold a square in half.

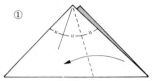

① Fold after dividing the top angle in three equal parts.

② Fold on top.

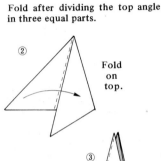

③ Lift top triangle so it stands up, then open and flatten.

④ Top layer only goes to the left.

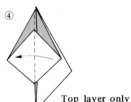

⑤ Same as step 3

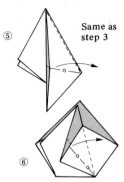

⑥ Lift last flap, open and flatten.

⑦ Same as the right side

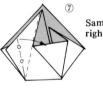

⑧ Turn and repeat.

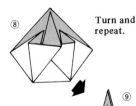

⑨ Fold points down.

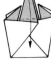

⑩ Tuck both tips under.

⑪ Open and turn sideways.

⑫ Fold both sides down.

Diagonal view

⑬ Fold flaps back on themselves.

Turn over and give the cap a rounded shape.

⑭ Completion

◆ **Peaked Cap** (page 76)

■ Start with the nurse's cap, step 12.

① Roll one point up.

② Half way

③ Flatten the rolled part and turn so the front is facing you.

④ Make these folds and turn the cap upside down.

⑤ Pull the front and back further apart, and turn right side up.

⑥ Completion

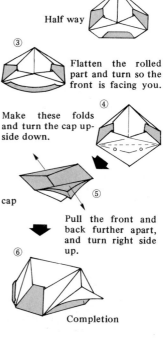

◆ Medicine Packet (page 20-21)

■ Start with a square folded in two.

①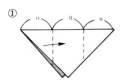

Fold the left third to the right.

②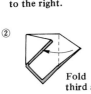

Fold the right third and tuck in.

▽

③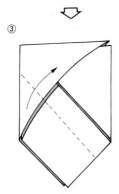

④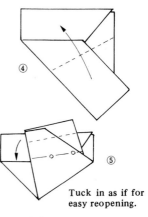

⑤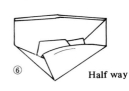

Tuck in as if for easy reopening.

⑥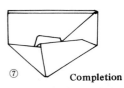

Half way

⑦

Completion

■ These old-style medicine packets were always made of white paper only. With colored paper they look much more cheerful. You can use this folding method for any size of flat gift.

◈ Flat Purse (page 57)

- Start with medicine packet, step 3.

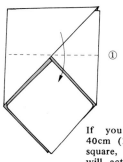

① If you use a 40cm (16 inch) square, money will actually fit into the purse.

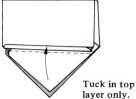

② Tuck in top layer only.

③ Half way

④ Turn over.

⑤

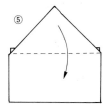

⑥

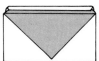

Your purse is finished. Now put something in it!

◆ Squid (page 29)

■ Start with a rectangle (ratio of sides is 2:3).

①

②

Fold the whole corner at once.

③

Again fold the whole corner over.

④

Reopen to step 2 position.

⑤

Using previous fold line, fold in and down.

⑥

⑦

Same as upper half

⑧

Step fold at center line.

⑨

⑩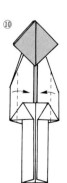

102

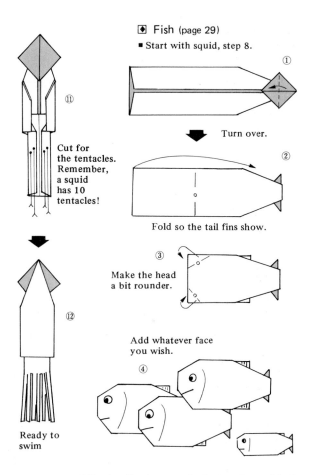

◆ Fish (page 29)

- Start with squid, step 8.

①

Turn over.

②

Fold so the tail fins show.

③

Make the head a bit rounder.

Add whatever face you wish.

④

⑪

Cut for the tentacles. Remember, a squid has 10 tentacles!

⑫

Ready to swim

- By lengthening or shortening the original rectangle, you can make fatter or thinner fish.

◆ Horned Beetle (page 32)

■ Start with basic fold A. (Page 119)

①

② Half way

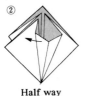

③ Make this fold 4 times altogether.

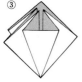

④ 4 flaps on each side. Fold top flap over to the right, bottom one over to the left.

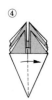

⑤ Fold to the center line and reopen.

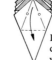

⑥ Like the crane's wing

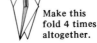

⑦ Make this fold 4 times altogether.

⑧ Same number of flaps on both sides, with opening down the middle. Fold in thirds. Reopen.

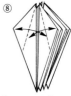

⑨

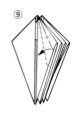

⑩ See page 110, step 2.

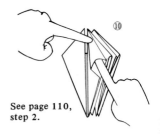

104

⑪

Fold left side
likewise.

⑫

Fold flaps
under.

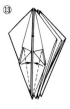

⑬

Top layer
only

⑭

Fold the right, left
and under sides like-
wise, following steps
8-14.

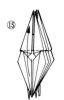

⑮

Same number of
flaps on both sides.
Fold one leg up so
it sticks out a bit
beyond top points.

⑯

Fold two flaps over
from left to right.

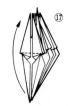

⑰

Fold second leg up,
sticking out a bit
like first leg.

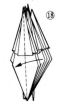

⑱

Fold 4 flaps over
from right to left.

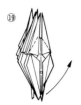

Make valley folds first.

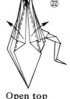

Open top layers away from center.

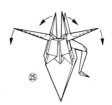

Hood fold on middle legs. Reverse fold on front legs.

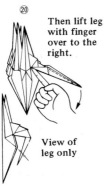

Then lift leg with finger over to the right.

View of leg only

Fold as deeply as possible.

Reverse fold again on front legs.

Fold 2 flaps over to the right.

Looking closely at angle and depth of step 25, fold middle legs out from center (reverse fold).

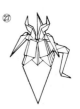

Hood fold again on middle legs, and turn.

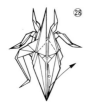

28

Fold hind leg up as
in steps 19 and 20.

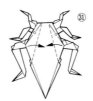

31

Make the
mountain folds
first.

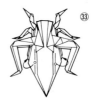

33

Do the same with
the 3 under layers
on both sides.

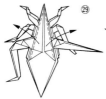

29

Same as left hind
leg. Open top layers
out.

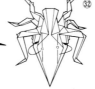

32

Fold the side
flaps under.

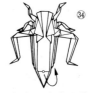

34

Fold the whole tail
tip under. Press
firmly.

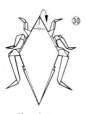

30

Top layer
only

■ This will look alive when
you add antennae!

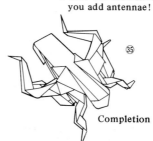

35

Completion

107

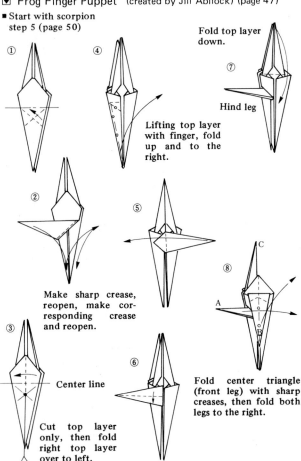

◆ Frog Finger Puppet (created by Jill Abilock) (page 47)

■ Start with scorpion
step 5 (page 50)

①

④

Fold top layer
down.

⑦

Lifting top layer
with finger, fold
up and to the
right.

Hind leg

②

⑤

Make sharp crease,
reopen, make cor-
responding crease
and reopen.

⑧

C

A

B

③

⑥

Center line

Cut top layer
only, then fold
right top layer
over to left.

Fold center triangle
(front leg) with sharp
creases, then fold both
legs to the right.

108

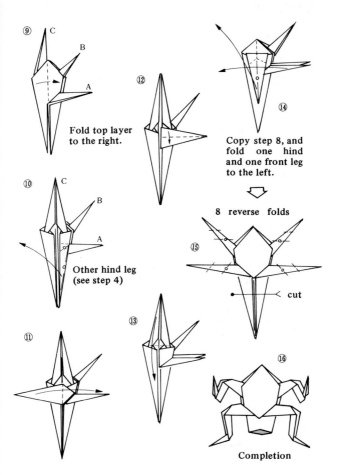

⑨ C B A

Fold top layer to the right.

⑩ C B A

Other hind leg (see step 4)

⑪

⑫

⑬

⑭ Copy step 8, and fold one hind and one front leg to the left.

8 reverse folds

⑮ cut

⑯ Completion

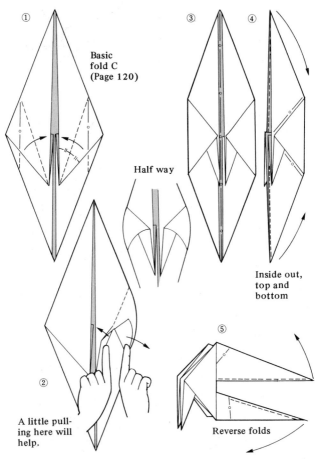

① Basic fold C (Page 120)

② A little pulling here will help.

Half way

③

④ Inside out, top and bottom

⑤ Reverse folds

110

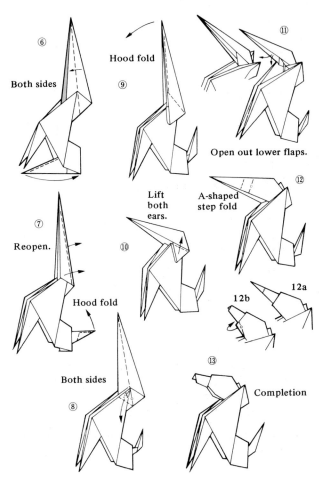

⑥ Both sides

Hood fold

⑨

⑪

Open out lower flaps.

⑦ Reopen.

Hood fold

Lift
both
ears.

⑩

A-shaped
step fold

⑫

12a

12b

Both sides

⑧

⑬

Completion

◈ Crane Origami Sculpture (page 68)

- Use a sheet 25 x 25 cm (10" x10"), preferably with a different color on each side. The crane itself is folded like the crane on page 10.

①

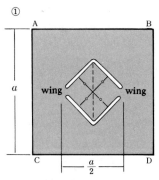

Make slits following the diagram, and use basic fold A (Page 119) on the square in the center.

③

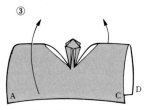

Turning the frame inside out, use basic fold B (Page 119) on the crane.

②

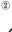

Fold the front and back the same way.

④

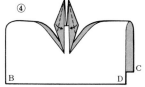

Make both front and back slimmer; then with reverse folds, make the neck and tail. Do the head last.

⑤ Top diagonal view

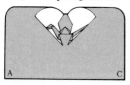

Carefully pull the wings apart to puff out the body.

⑥

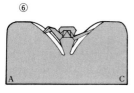

⑦

Apply glue to the shaded part, and stick AC to BD.

NB. A stick-type glue is easier to use than a liquid.

Completion

⑧

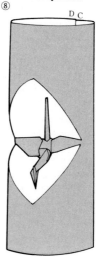

■ Instead of a crane, you can use a four-pointed basket in this sculpture if you wish.

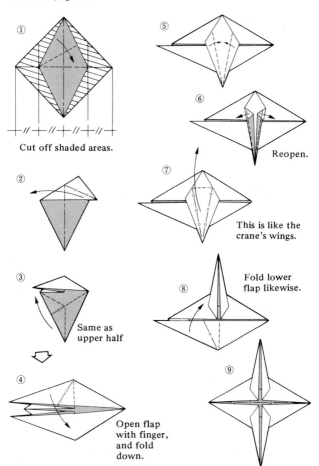

① Cut off shaded areas.

②

③ Same as upper half

④ Open flap with finger, and fold down.

⑤

⑥ Reopen.

⑦ This is like the crane's wings.

⑧ Fold lower flap likewise.

⑨

114

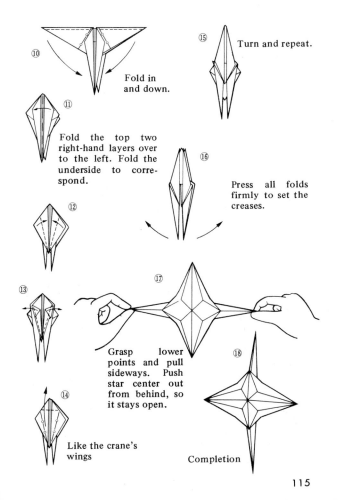

⑩ Fold in and down.

⑪ Fold the top two right-hand layers over to the left. Fold the underside to correspond.

⑫

⑬

⑭ Like the crane's wings

⑮ Turn and repeat.

⑯ Press all folds firmly to set the creases.

⑰ Grasp lower points and pull sideways. Push star center out from behind, so it stays open.

⑱ Completion

■ Start with 2 attached squares.

①

After making all the folds,
close the left half as shown.

②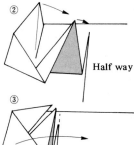

Half way

③

Fold this entire
square over onto
the notepaper.

④

Making a valley fold in
the top layer only,
make sure the under-
neath flaps point down.

⑤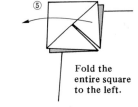

Fold the
entire square
to the left.

⑥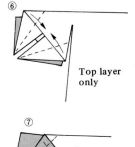

Top layer
only

⑦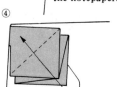

Fold in half
again.

⑧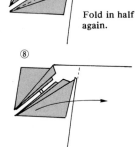

116

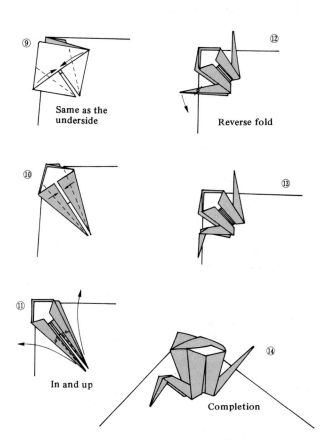

⑨ Same as the
underside

⑩

⑪ In and up

⑫ Reverse fold

⑬

⑭ Completion

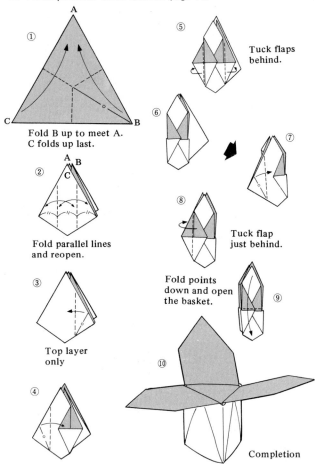

① Fold B up to meet A.
C folds up last.

② Fold parallel lines
and reopen.

③ Top layer
only

④

⑤ Tuck flaps
behind.

⑥

⑦

⑧ Tuck flap
just behind.

Fold points
down and open
the basket.

⑨

⑩ Completion

◈ Basic Fold A

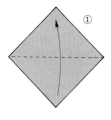

①

②

③

Top layer only

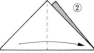

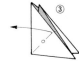

④

Half way

⑤

Keep all points together.
Turn over.

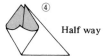

⑥

All points together

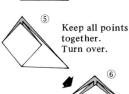

◈ Basic Fold B

- Start with basic fold A.

①

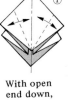

With open end down, fold and reopen.

②

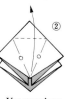

Use previous fold lines.

③

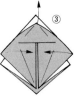

Half way

④

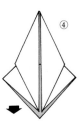

Turn over.

⑤

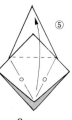

Same as steps 1 and 2

⑥

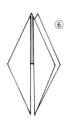

◆ Basic Fold C

①

◆ Basic Fold D

■ Start with basic fold C.

①

Turn over.

②

Top layer only

②

③

③

④

◉ Basic Fold E

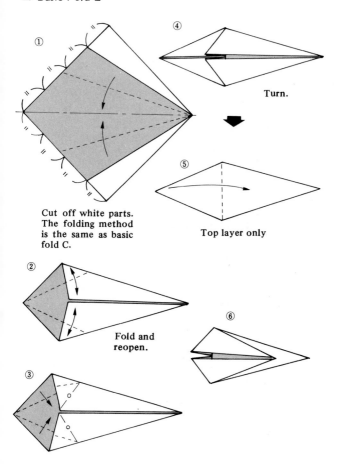

① Cut off white parts. The folding method is the same as basic fold C.

② Fold and reopen.

③

④ Turn.

⑤ Top layer only

⑥

121

◆ Basic Fold F

- This folding method is also used in basic fold A. (Page 119)

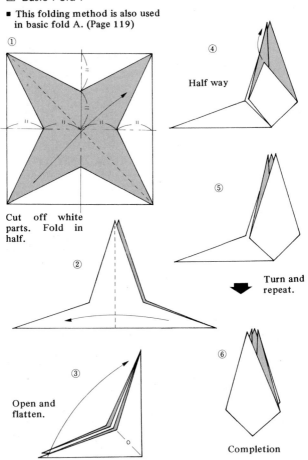

① Cut off white parts. Fold in half.

②

③ Open and flatten.

④ Half way

⑤ Turn and repeat.

⑥ Completion

122

◈ Basic Fold G

■ This is basic fold C (Page 120) on the right half of the paper.

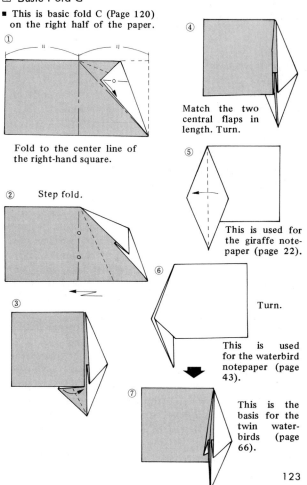

① Fold to the center line of the right-hand square.

② Step fold.

③

④ Match the two central flaps in length. Turn.

⑤ This is used for the giraffe notepaper (page 22).

⑥ Turn.

This is used for the waterbird notepaper (page 43).

⑦ This is the basis for the twin water-birds (page 66).

Translator's Note

Origami has a danger in it you may not have realized. It is highly addictive! Surprisingly, it doesn't get much attention from adults, and many of my friends are amazed to hear that my cultural visa for study in Japan is based, in part, on origami. Admittedly the exquisite creatures that Takuji Sugimura turns out quickly and effortlessly look quite easy to make. However, like a lot of Japanese art forms, a great deal of time and care go into these "simple" creations. Takuji has been my teacher for four years, and with unflagging enthusiasm and infinite patience has made origami for me a truly expanding art form. Its initial attraction is the pleasure it brings. The next discovery is the effort and concentration needed to produce origami without railroad tracks and with tips and corners that have only one sharp point to them! But the real fascination is the absolutely limitless horizon that opens up when you start experimenting. In this book Takuji has tried to outline some of the ways he has found to expand on traditional forms, in hopes of encouraging you to let your fingers and your imagination carry you away. And he is always eager to learn from others, so if you have ideas to share, or questions to ask, please write to him. He would like to see as many people hooked on origami as possible! Takuji Sugimura, 2-15-11 Oe-Kitafukunishi-cho, Nishikyo-Ku, Kyoto, 610-11 Japan.

Catherine Arthurs